HAPPINESS
through conformity

CONFORMITY
through influence

INFLUENCE
through spin

◆

 Wolf&Co.

◆

At *Wolf&Co.* we're proud to say that we're in the good business of making people feel happy. Happy to stand in line, out of fear of being laughed at or called names.

But this is no easy task for us. In fact we often have to tell small lies to get the herd moving in the right direction. Spin the truth when necessary and choose between the carrot, stick or torture rack.

Thus it is hardcore propaganda which we recommend – and you must now study in order to master the black art of Spinfluence.

Relax Young Cub, it's a real hoot.

ISBN 978-1-908211-11-8

A catalogue record for this book is available
from the British Library.

First published in Great Britain in 2013
by Carpet Bombing Culture

www.carpetbombingculture.com
email: books@carpetbombingculture.co.uk
© Carpet Bombing Culture

Nick McFarlane 2013

The right of Nick McFarlane to be identified as
the author of this work has been asserted by him
in accordance with the Copyright, Designs and
Patents Act 1988.

The author,

Nicholas McFarlane

Presents

SPINFLUENCE

— THE —

HARDCORE
PROPAGANDA
MANUAL

FOR CONTROLLING
THE MASSES

— *to* —

I, the undersigned Young Cub agree, as part of
my indoctrination process, to read and study all
of the ten steps contained within this manual.

SIGNED: DATE:

LEARN HOW TO CONTROL THE MASSES IN 10 STEPS:

████████████████████████████████

██████████ to draw your attention to a small, yet █████ issue facing our happy organisation – and invite you to consider its consequences before pledging your allegiance to *Wolf&Co.* and our corporate agenda.

SPIN:

The technique in which language is used to propagate a biased idea or interpretation of events.

SPINFLUENCE:

The power and influence which spin exerts over a person's thoughts, feelings and behaviour.

1

STEP 1: SPINFLUENCE

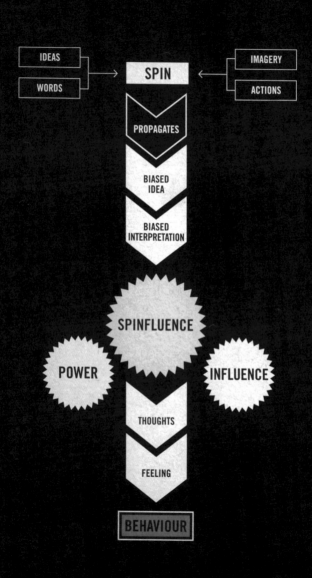

1.0 SPINFLUENCE

Spinfluence is most successful when the audience remains oblivious to the use of spin, believing instead that their behaviour is the result of their own independent thinking.

Language and semiotics are used to propagate a biased idea or interpretation of events.

Through this method, your audience is free to enjoy happiness through conformity.

Ideas are ammo

Ideas are the ammunition aimed at head and heart.

Simple ideas are often the most explosive as they connect with the widest range of people.

But what makes an idea truly deadly is how it's delivered.

Primarily through language
& how things are labeled

 | Richard Stengel, *The Power of Ideas, Time Magazine*, 2008

"Ideas change the world. The power of a new idea is the engine that transforms the way we live and think. (Our country was founded on one.) It was almost 50 years ago that the philosopher Thomas Kuhn coined the term paradigm shift – the moment when our world view fundamentally changes because of a new idea, as when people understood that the sun does not revolve around the earth or that climate change is altering the way we would all have to live."

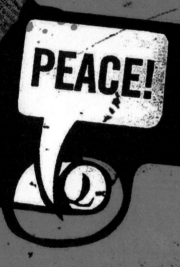

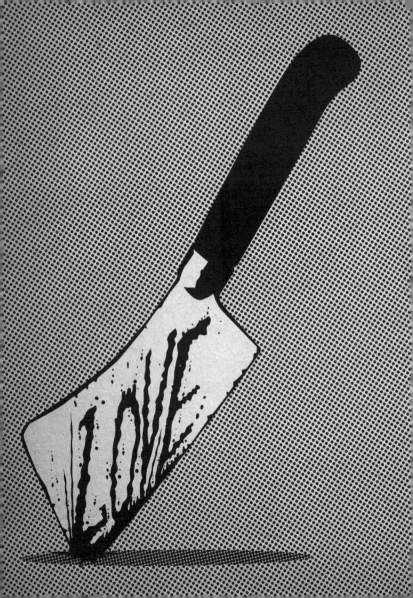

Words are weapons

Words are the most lethal weapons used in the battle for hearts and minds.

Sound bites and slogans are used to deliver persuasive messages and subversive ideas.

 Steven Poole, *Unspeak. Words are Weapons*, 2006

"These precision-engineered packages of language are launched by politicians and campaigners, and targeted at newspaper headlines and snazzy television graphics, where they land and dispense their payload of persuasion into the public consciousness."

Imagery which electrifies

Images have the unparalleled ability to affect the mind and to leave a lasting impression.

A strong and graphic image has the power to both shock and seduce.

Visuals succeed where words fail, by condensing multiple layers of meaning into one symbolic image.

 | Wolf&Co. *Distort-optics Dept*, 1987

"Huynh Cong Ut's iconic image taken during the Vietnam War of fleeing children, focusing on a nude girl whose clothes had been melted off by a napalm bomb, in one instant, dramatically affected the world's perception of the Vietnam conflict."

Actions cause impact

Action is the embodiment of an idea or belief.

Action gives significance to words and imagery.

It makes real what would otherwise be only rhetorical, visual or wishful.

Sometimes the flames need to be real for us to fear them properly.

Eg. | Wolf&Co. *Vexation Dept*, 1982

"The symbolic fire at the Reichstag (German Parliament) allowed Hitler to speed up and consolidate the Nazi Party's authority. By interpreting it as a Communist arson attack, a decree was passed which suspended many civil liberties such as freedom of the press. This helped in establishing the dictatorship and one-party Nazi state in Germany."

Propaganda hammers the message

Propaganda is the tool used to turn ideas, words, images and actions into persuasive and influential messages.

The basic materials with which propaganda works are:

- Rhetorical devices
- Influential imagery
- Symbolic action

Eg. | Noam Chomsky, *Media Control*, 1991

"Propaganda is to a democracy what the bludgeon is to a totalitarian state."

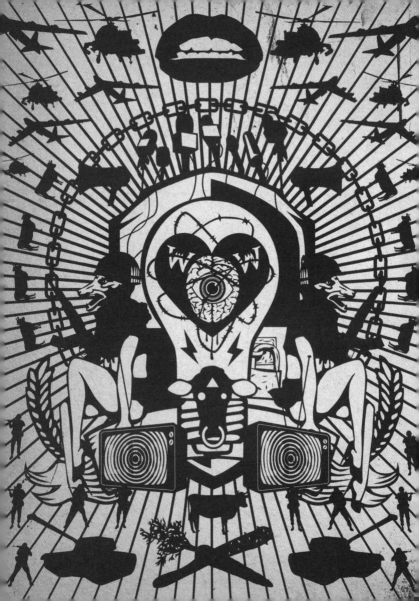

The battle for hearts and minds

The mental and emotional territory must be conquered if control of the masses is to be achieved. ~~The role~~

Propaganda is used not only to attack and seduce the senses but to also build a fortress around weak arguments.

Eg. | Robert Greene, *The Concise 33 Strategies of War,* 2006

"Communication is a kind of war, its field of battle the resistant and defensive minds of the people you want to influence. The goal is to advance, to penetrate their defences and occupy their minds..."

LE
DAY

WON'T KEEP THE SPIN DOCTOR AWAY

① HOW TO BE HAPPY:

The best
medicine you
can provide.
Is a stern
warning you'll
tan their hide.

STEP 2: PROPAGANDA

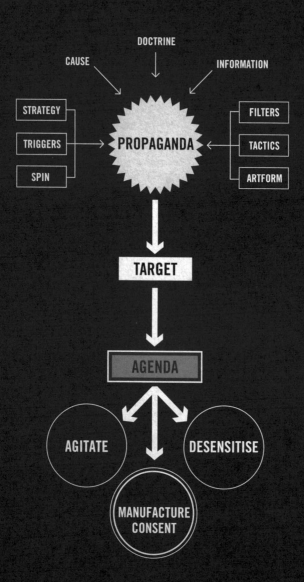

2.0 PROPAGANDA

Integral to spinfluence is propaganda.

Propaganda is the deliberate, systematic attempt to shape perceptions, manipulate cognitions and direct behaviour to achieve a response that furthers the desired intent of the *wolf*.

This chapter examines the who, what, when, where, why and how of propaganda.

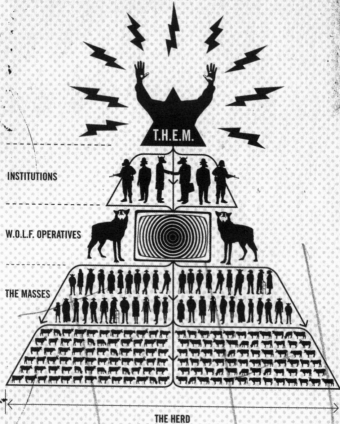

INSTITUTIONS

W.O.L.F. OPERATIVES

THE MASSES

T.H.E.M.

THE HERD

Who?

Propaganda involves communication aimed at the masses by an elite minority who's hidden agenda is to control the herd.

As a propaganda agency, it is our task to keep *them* protected at the top of the pyramid, from the unruly and bewildered herd beneath. ▬▬▬▬▬▬▬

Eg. | Dan Gilmor, *The Guardian*. 23/11/11

"If we know anything about the recent income and accumulated assets of the now notorious 1%, it is that much of this wealth, by any rational standard, is undeserved. This applies especially to the Wall Street bankers who looted the global economy with sleazy tactics and, sadly, also with impunity."

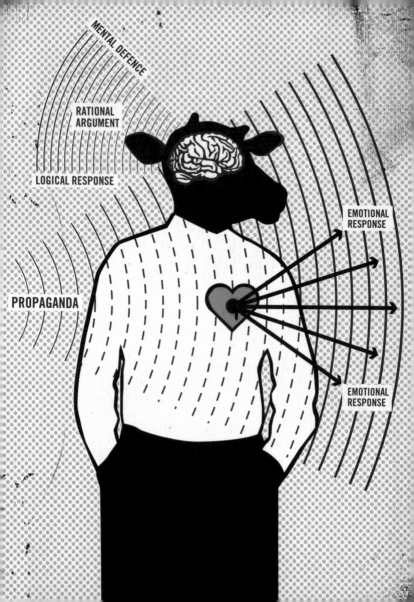

What?

Put ideas in their head by hitting the heart...

Propaganda is characterised by its selective presentation of language and falsities in order to encourage a specific way of thinking.

It's purpose is to communicate a biased agenda with loaded messages intended to produce an emotional, rather than rational response.

 | Edward Bernays, *Propaganda*, 1928

"Modern propaganda is a consistent, enduring effort to create or shape events to influence the relations of the public to an enterprise, idea or group. [It involves the] practice of creating circumstances and for creating pictures in the minds of millions of persons."

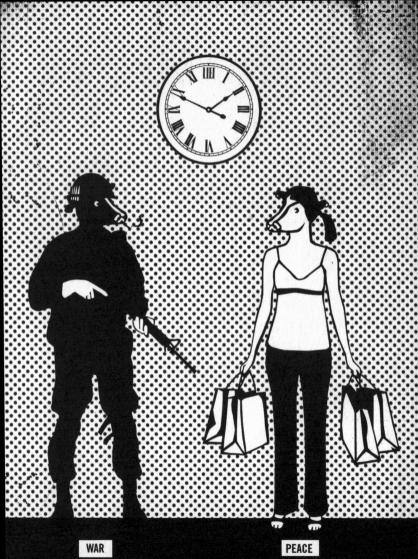

When?

Propaganda is used during both times of war and peace.

In wartime, it is used to galvanise the public behind the government's participation in the conflict.

During times of peace, it is used to maintain the public's docile happiness, primarily through the encouragement of cyclic consumer behaviour.

 Alec Carey *(Psychologist)*, 1995

"The twentieth century has been characterized by three developments of great political importance: the growth of democracy, the growth of corporate power, and the growth of corporate propaganda as a means of protecting corporate power against democracy."

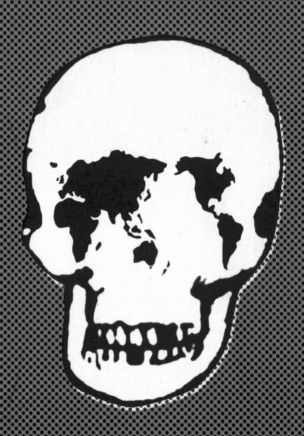

Where?

or it is used with violence. Carrot AND stick.

Propaganda is used globally in societies where overt physical force is no longer permitted.

Propaganda has become the preferred tool for use in public opinion management.

Wherever a small minority of people seek to rule the larger majority, you will find it to be in use.

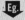 | Jacques Ellul, French philosopher. 1912–1994.

"The orchestration of press, radio and television to create a continuous, lasting and total environment renders the influence of propaganda virtually unnoticed precisely because it creates a constant environment."

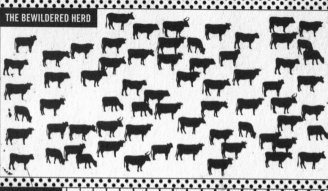

THE BEWILDERED HERD

SPINFLUENCE

INFLUENCED BEHAVIOUR PATTERN

Why?

The primary objective of all good propaganda is to achieve ██████████ through Spinfluence.

By influencing behavioural patterns *they* can control and consolidate power over the masses. With the herd standing in line, enjoying docile content-ment, *they* are able to pillage and plunder at will.

← From disorder to order Controlled by spin →

Eg. | Edward S. Herman & Noam Chomsky, *Manufacturing Consent*, 1988

"The mass media serve as a system for communicating messages and symbols to the general populace. It is their function to amuse, entertain, and inform, and to inculcate individuals with the values, beliefs, and codes of behaviour that will integrate them into the institutional structures of the larger society. In a world of concentrated wealth and major conflicts of class interest, to fulfil this role requires systematic propaganda."

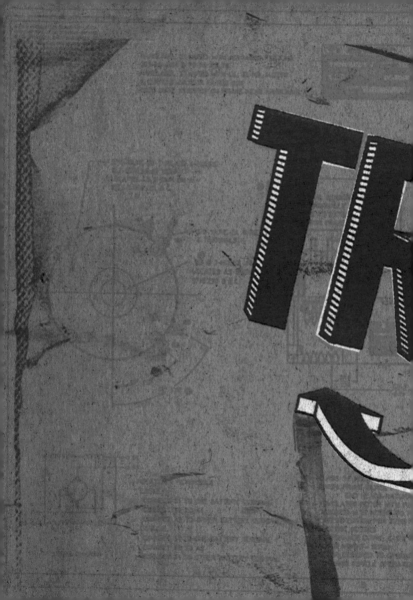

How?

To hide or to spin? That is the question. Censorship may be an effective method of thought control, but it is the ability to distort the truth which requires greater skill.

Through the manipulation and exploitation of lingual and visual ambiguities the conjurer is able to pull falsities out of fact, as if by magic

Eg. | *Sourcewatch.com*, 2011

"According to a recent study by the US Union of Concerned Scientists, [ExxonMobil] has spent more than $19 million to promote skepticism about global warming, funding think tanks, publications and web sites that are not peer reviewed by the scientific community."

THEN

HUF

P

STEP 3: THE HERD

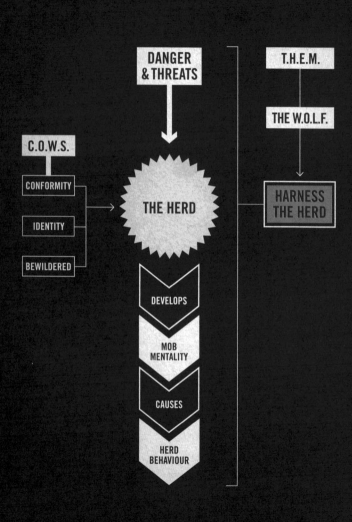

3.0 *THE HERD*

As with other species in the animal kingdom, when confronted with danger, people will retreat within the protection of a group.

Without leadership, this group has the potential to act in a bewildered manner – allowing for mob mentality to arise.

The *wolf* will purposely aim to provoke this type of behaviour.

*In this way the **wolf** can harness not just one **cow**, but the herd.*

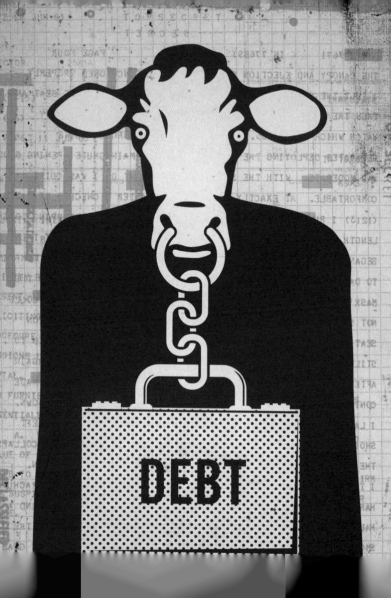

C.O.W.S.

Corporation Owned Wage Slaves: People who, straddled with debt are forced into a continuous cycle of long hours and servitude to their corporate masters.

In this position, *cows*[*] rarely challenge authority, instead focusing on their own financial hardships.

[*]Corporation Owned Wage Slaves will henceforth be referred to simply as *cows*.

Eg. | Peter Joseph. *Zeitgeist: Addendum, 2008*

"Money is created out of debt. And what do people do when they are in debt? They submit to employment to pay it off. It is the fear of losing assets, coupled with the perpetual debt and inflation inherent in the [economic] system... that keeps the wage slave in line. Running on a hampster wheel with millions of others, in effect powering an empire which truly benefits only the elite at the top of the pyramid."

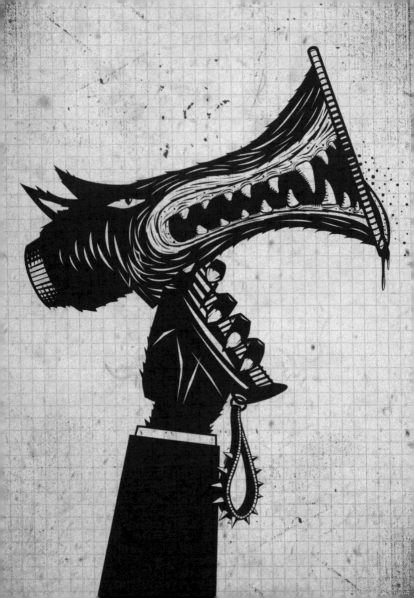

The W.O.L.F.

It is the responsibility of the Warden Of Language & Falsities[*] to ensure our version of the truth is always the most persuasive.

The *wolf* will combine cunning and stealth to frighten not just a few *cows* but indeed the broad masses of the herd.

[*] A Warden Of Language & Falsities will henceforth be referred to simply as a *wolf*.

 | Joseph Goebbels (Reich Minister of Propaganda), 1928

"Success is the important thing. Propaganda is not a matter for average minds, but rather a matter for practitioners. It is not supposed to be lovely or theoretically correct... The point of a political speech is to persuade people of what we think right... Propaganda should be popular, not intellectually pleasing."

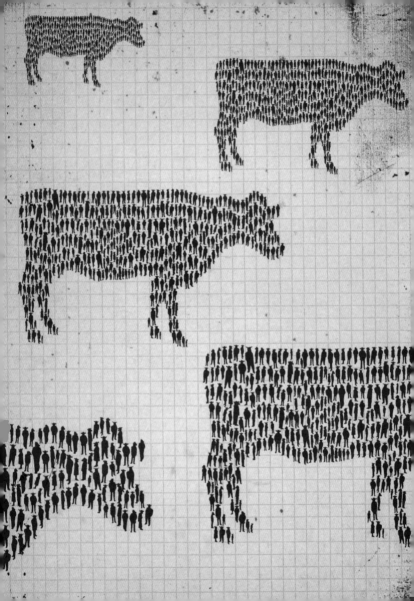

Herd behaviour

The phenomenon where groups of *cows* act in the same ~~behaviour~~ way at the same time.

By adopting an indistinct profile from his peers, or by mimicking those around, the individual is able to minimise his exposure to risk.

this is how group parameters become established.
people instinctively know which boundaries not to cross

 Dan Gardner, *Risk. The science and politics of Fear*, 2009

"From an evolutionary perspective, the human tendency to conform is not so strange. Individual survival depended on the group working together and cooperation is much more likely if people share a desire to agree. A band of doubters, dissenters, and proud nonconformists would not do so well hunting and gathering on the plains of Africa."

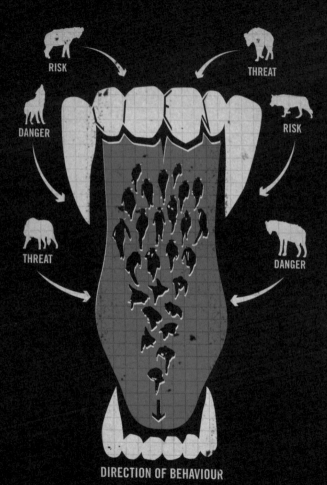

RISK

THREAT

DANGER

RISK

THREAT

DANGER

DIRECTION OF BEHAVIOUR

Danger and threats

Danger and threats to an individual can be of a physical or emotional nature.

In a potentially threatening situation *cows* will invariably react with a primal fight or flight response.

'Safety in numbers' as a strategy allows both the group and the individuals to preserve their security and minimise risk.

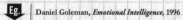 Daniel Goleman, *Emotional Intelligence*, 1996

"Given the roots of anger in the fight wing of the fight-or-flight response, it is no surprise... that a universal trigger for anger is the sense of being endangered. Endangerment can be signalled not just by an outright physical threat but also, as is more often the case, by a symbolic threat to self-esteem or dignity: being treated unjustly or rudely, being insulted or demeaned, being frustrated in pursuit of an important goal."

Conformity

Conformity to the group helps maintain both safety and status.

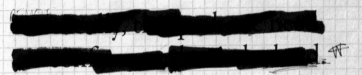

Non-conformists may be seen as a liability and, left outside the group, they are forced to fend for themselves.

Eg. | Michael Crichton, *The Lost World*, 1995

"The characteristic human trait is not awareness but conformity, and the characteristic result is religious warfare. Other animals fight for territory or food; but, uniquely in the animal kingdom, human beings fight for their 'beliefs'. The reason is that 'beliefs' guide behavior, which has evolutionary importance among human beings."

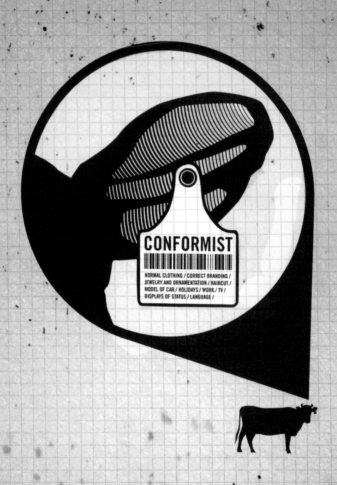

CONFORMIST

NORMAL CLOTHING / CORRECT BRANDING /
JEWELRY AND ORNAMENTATION / HAIRCUT /
MODEL OF CAR / HOLIDAYS / WORK / TV /
DISPLAYS OF STATUS / LANGUAGE /

Herd identity

A herd's identity develops through its individuals' combined adherence to an ideology.

By acknowledging and displaying relevant symbols of conformity, the individual can move closer to the centre of group acceptance.

In turn, this self-serving behaviour reinforces the herd's identity.

 Eg. | Neil Boorman, *Bonfire of the Brands,* 2007

"Teenagers use the symbolism of their favourite brands during the construction of their identity, gaining a sense of belonging when they use the same brands as those in their peer group. Mobile phones in particular are an important mark of acceptance within social groups, each using different covers, ringtones and glue-on jewelry to express their individuality."

The bewildered herd

Lacking confidence and in a state of anxiety, the herd is prone to acting in an erratic and unpredictable manner as the *cows* put their immediate concerns ahead of their long term and collective well-being.

The bewildered herd is a phrase coined by Walter Lipman

Eg. | Noam Chomsky, *Media Control*, 1991

"We have to tame the bewildered herd, not allow the bewildered herd to rage and trample and destroy things. It's pretty much the same logic that says that it would be improper to let a three-year-old run across the street. You don't give the three-year-old that kind of freedom because the three-year-old doesn't know how to handle that freedom. Correspondingly, you don't allow the bewildered herd to become participant in [democracy]. They'll just cause trouble."

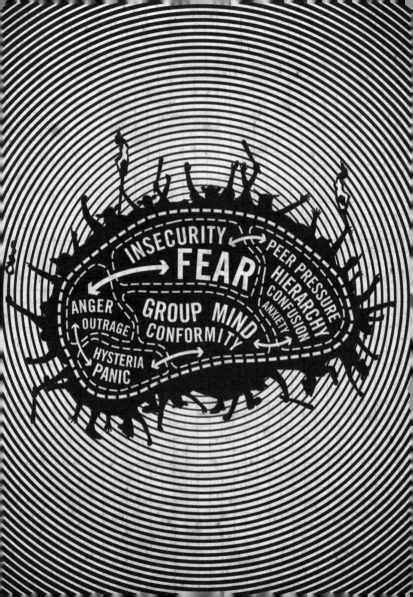

Mob mentality

A form of group-psychosis in which peer pressure and a fear of being isolated, sweeps all *cows* away individually, whilst binding them together in a form of mass hysteria.

In this state it is not the most reasoned or intelligent who lead the herd, but merely the whim of the strongest or most feared.

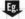 Edward Bernays, *Propaganda*, 1928

"The group mind does not think in the strict sense of the word. In place of thoughts it has impulses, habits and emotions. In making up its mind, its first impulse is usually to follow the example of a trusted leader. This is one of the most firmly established principles of mass psychology."

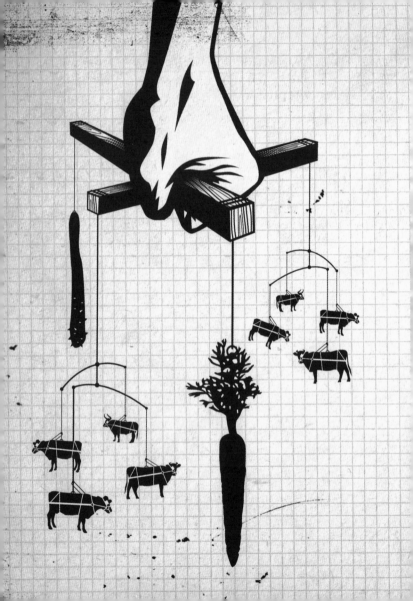

Harnessing the herd

Propaganda is used as a social harness which subliminally conveys appropriate threat and reward messages to control the herd's energy and behaviour, allowing the herd to be directed as *they* desire.

It is often a delicate balancing act when deciding between the carrot or the stick.

Eg. | Edward Bernays, *Propaganda*, 1928

"We are governed, our minds are moulded, our tastes are formed, our ideas suggested, largely by men we have never heard of... It is they who pull the wires which control the public mind, who harness old social forces and contrive new ways to bind and guide the world."

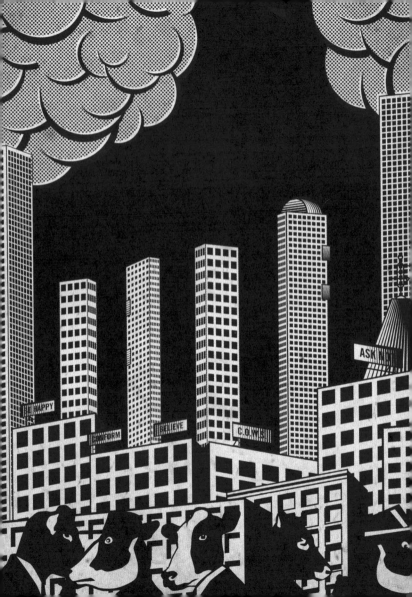

T.H.E.M.

The Hidden Elite Minority[*]
are the true rulers of the world.
They reach down in the cover
of darkness to influence ████,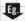
governments, banking groups,
corporations, military and
intelligence networks.
Through these institutions,
they wield ultimate control.

[*]The Hidden Elite Minority will henceforth be referred
to simply as *them* or *they* where necessary.

Eg. | Joseph E. Stiglitz, *Vanity Fair.* May 2011.

"The Supreme Court, in its recent Citizens United case, has enshrined the right of
corporations to buy government, by removing limitations on campaign spending.
The personal and the political are today in perfect alignment. Virtually all U.S.
senators, and most of the representatives in the House, are members of the top
1 percent when they arrive, are kept in office by money from the top 1 percent,
and know that if they serve the top 1 percent well they will be rewarded by the
top 1 percent when they leave office."

NOT

WHAT T.H.E.Y. CAN DO FOR YOU,

BUT WHAT YOU CAN DO FOR T.H.E.M.

3

HOW TO BE HAPPY:

Forget about being patriotic. If you're not serving T.H.E.M. you're being idiotic.

STEP 4: STRATEGY

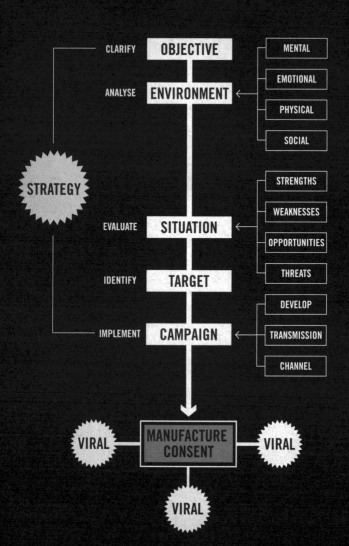

The objective of propaganda is to manage public opinion and manufacture the consent of the masses. Ideally, any new behaviour patterns will become virally self-perpetuating.

Planning a strategy for these ends requires comprehensive analysis and evaluation of the environment and situation.

Spinfluence needs to be built around an idea which has the potential for strong spin.

NARRATIVE: ACTIVE PARTICIPATION REQUIRED

ENCOURAGE

AGITATE

DESENSITISE

SUPPRESS

NARRATIVE: SUBMISSIVE BEHAVIOUR EXPECTED

Clarify objective

The tactical objectives
of propaganda are:

- Control the narrative.

- Arouse the interest
 of a specific group.

- Nullify unhelpful ideas.

- Agitate or desensitise
 the emotional state
 of the target audience.

Eg. | Wolf&Co. *Planning Dept,* 1995

"During wartime, propaganda is used to mobilise the masses. Provoke hatred of
the enemy. Desensitise civilians to the atrocities committed by their own regime.
Demoralise the enemy. Preserve friendship of allies and influence neutral parties."

STRATEGY 4.2

Analyse the environment

DELETE

The mental, emotional, physical and social environments are analysed in order to provide critical insight into the target audience's hopes, fears, dreams and desires.

Eg. | Wolf&Co. *Strategy Dept, 2008*

"There are now over 4.2 million CCTV cameras in the UK, more than one for every 14 people. Over 600 agencies are now authorised to access personal records. The National DNA Database permanently holds the details of nearly 4 million individuals. This degree of monitoring and surveillance allows for a very comprehensive analysis of the characteristics of society."

Evaluate the situation

Feelers are put out to evaluate the situation and detect opportunities for gain.

In this way, circumstantial strengths and weaknesses are flagged, and potential threats detected sooner rather than later.

Keep your friends close. And your enemies closer.

Eg. | Sun Tzu, *The Art of War*, 6BC

"All warfare is based on deception. Hence, when able to attack, we must seem unable; when using our forces, we must seem inactive; when we are near, we must make the enemy believe that we are far away; when far away, we must make him believe we are near. Hold out baits to the enemy. Feign disorder, and crush him."

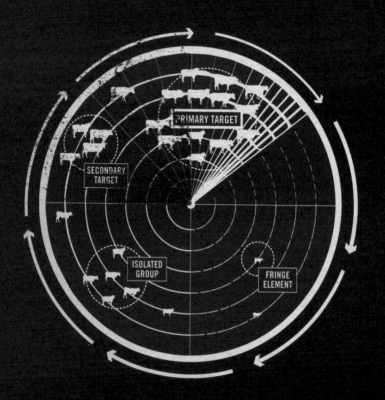

Identify the audience

Once the preliminary research is completed, the target audience becomes identifiable.

The target audience is the group whose role as early adopters of the desired behaviour is most required for our ~~██████████~~ propaganda to be effective.

 | Malcolm Gladwell, *The Tipping Point*, 2000

"The success of any kind of social epidemic is heavily dependent on the involvement of people with a particular and rare set of social gifts."

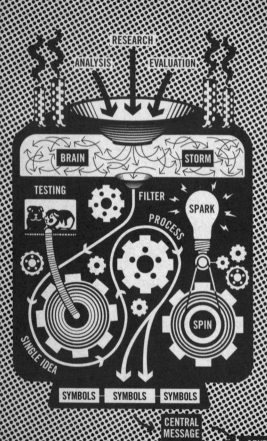

Develop campaign

Complex ideas are reduced down to their fundamental essence and condensed into symbolic messages.

Symbols are important as they are easily and immediately understood by a wide audience. They then play a key role in establishing the central message which is transmitted into the ongoing narrative.

 Andrew Sullivan, *The Australian*, 15/01/07

"Wars... are not just about guns and military action. They are also about ideas and ideology. Long wars, especially, are won by those who gain control of the narrative. The West won the Cold War when it became understood globally as a battle between totalitarianism and freedom."

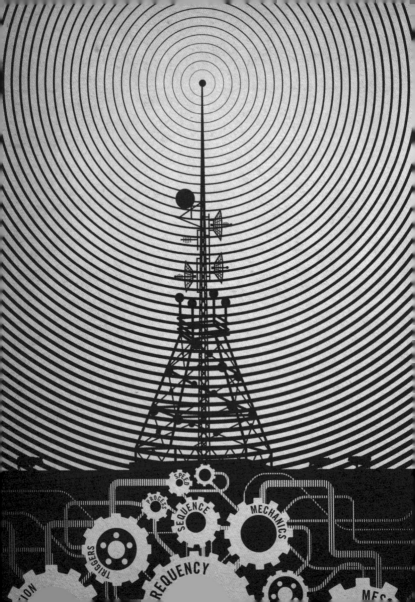

Transmission

Transmission is the action or process of broadcasting and disseminating the central message in the most effective, insidious or subversive manner.

Successful transmission relies on all components of the propaganda machine functioning smoothly, and as one.

 | thefullwiki.org/Propaganda

"Propaganda campaigns often follow a strategic transmission pattern to indoctrinate the target group. This may begin with a simple transmission such as a leaflet dropped from a plane or an advertisement. Generally these messages will contain directions on how to obtain more information, via a web site, hot line, radio program, et cetera (as it is seen also for selling purposes among other goals). The strategy intends to initiate the individual from information recipient to information seeker through reinforcement, and then from information seeker to opinion leader through indoctrination."

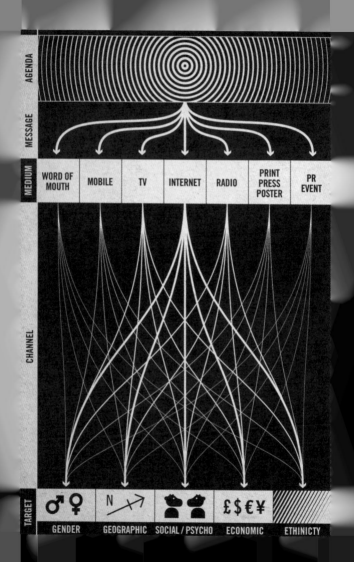

Channels

Traditional channels such as TV, radio and print still provide the widest reach to a broad target audience.

However, it is within the digital space – social media in particular, which is providing new and exciting methods of harnessing the herd.

 Eg. | Gee Thomson, *Mesmerization*, 2008

"New technology, the internet, broadband communications, mobile media and instant messaging have added an entirely new dimension to the power of such messages. Speed and rapid exponential growth have been added to the equation. Our contemporary commercial and media infrastructure, from lifestyle publishing to TV and the web, has both perfected the art of triggering emotional responses, using highly provocative visual metaphors, and providing a single and surprisingly coherent conduit for the worldwide dissemination and simplication of information."

STRATEGY 4.8

Viral

— Going viral to the point where it becomes an epidemic is the goal.

Memes are ideas which replicate and spread from person to person in a virally contagious manner through writing, speech, gestures, rituals or other imitable phenomena.

Highly contagious memes have the ability to spread like an epidemic, especially through social media.

Eg. | Gee Thomson. *Mesmerization,* 2008

"As well as spreading by word of mouth, memes are amplified by modern media: television, lifestyle magazines and now the internet. The large majority of memes which thrive today, by virtue of their repetition, volume, visibility and sheer weight in our media environment, are either commercial or conceal some commercial imperative."

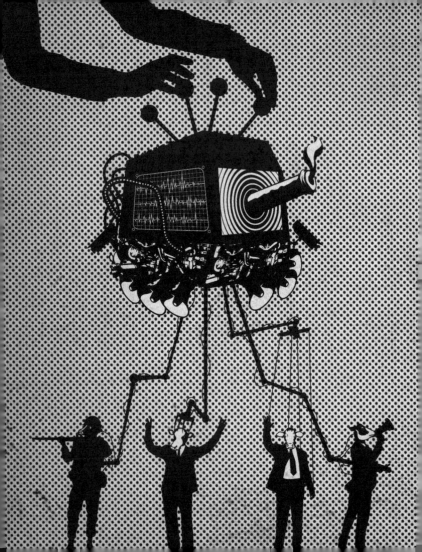

Manufacture consent

Public opinion is largely controlled through 'news' content which is broadcast through the mass media.

They are able to manufacture the consent of the masses by pressuring news outlets to ignore or place less emphasis on unfavourable news.

 Robert Greene, *The Concise 33 Strategies of War*, 2008

"People's perceptions are filtered through their emotions; they tend to interpret the world according to what they want to see. Feed their expectations, manufacture a reality to match their desires, and they will fool themselves. The best deceptions are based on ambiguity, mixing fact and fiction so that the one cannot be disentangled from the other. Control people's perceptions and you control them."

.F.
EP'S
CLOTHING

STEP 5: TARGET

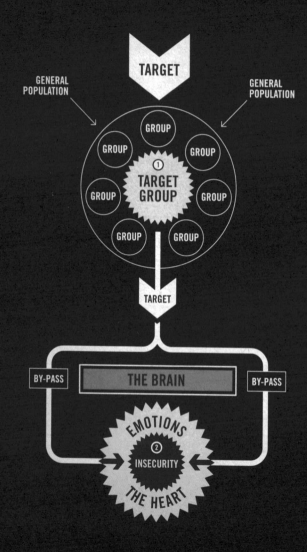

5.0 *TARGET*

Before spinfluence can work, the target must be identified on two levels:

1. Through social, geographic and economic demographics.

2. The heart: with its feelings and impulses which govern human behaviour at the most fundamental level.

Capture the heart and you capture the herd's happiness.

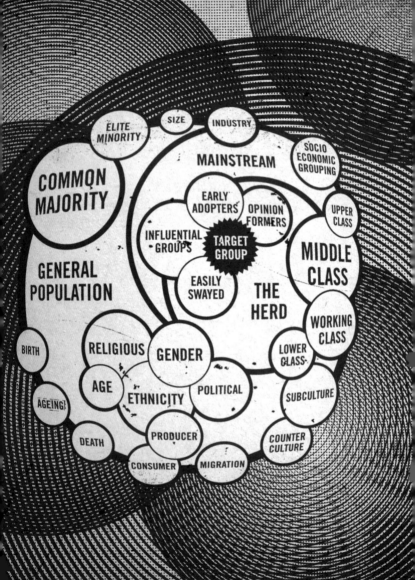

General population

Society is a complex melting pot of groups and subgroups who are in a continuous state of flux. There is a constant process of diversification, mutation and rejection, as these groups interact with one another. Understanding the big picture allows us to focus on the finer details.

 Eg. | Edward Bernays, *Propaganda*, 1928

"[Propaganda] takes account not merely of the individual, nor even of the mass mind alone, but also and especially of the anatomy of society, with its interlocking group formations and loyalties. It sees the individual not only as a cell in the social organism but as a cell organized into the social unit. Touch a nerve at a sensitive spot and you get an automatic response from specific members of the organism."

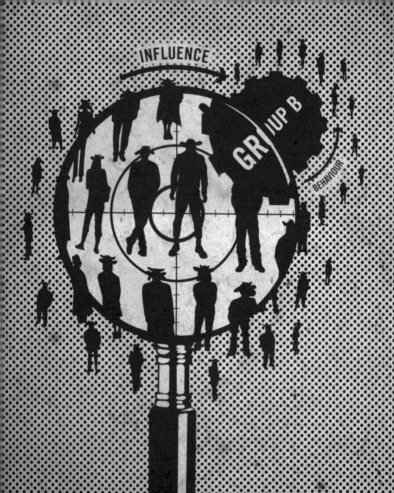

Target group

The target group is judged to hold a pivotal position within society, who will set the wheels of behavioural change in motion, through the influence they hold over other groups.

Therefore the propaganda produced must be tailored to their needs. *Thus the need for intelligent forward planning*

Eg. | Brian Solis, *Contagious*, Q2/09

"Motivating niche groups of enthusiasts may seem trivial, however, cultivating these specialized communities is the very thing that will install loyalty and trust, while sewing the seeds to ultimately empower an army of enthusiasts."

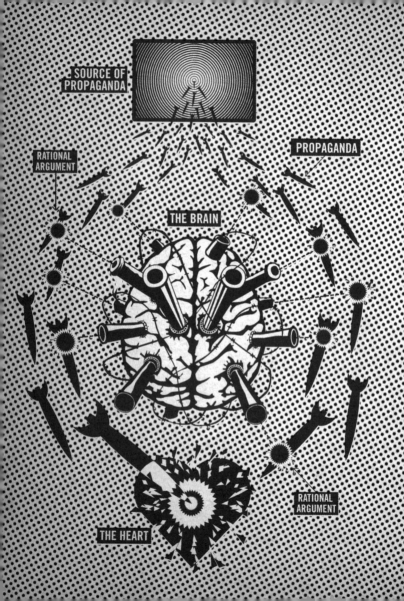

The brain

The brain is an obstacle
on route to the heart.

It has the ability to make
logical analysis and respond
to propaganda with rational
arguments.

Therefore, propaganda will
always seek to bypass it
in whichever way possible.

Eg. | William James, *Philosopher*, 1842–1910

"The greatest weapon against stress is our ability to choose one thought over another."

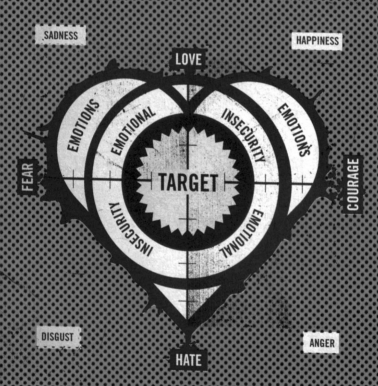

SADNESS

HAPPINESS

LOVE

EMOTIONS

EMOTIONAL

INSECURITY

EMOTIONS

FEAR

TARGET

COURAGE

INSECURITY

EMOTIONAL

DISGUST

ANGER

HATE

The heart

The heart sits at the core of human experience and it is where love, hate, fear and courage are commonly thought to reside.

It is emotions in which the *wolf* is most interested, as these can easily sway the decision-making process of the brain.

Eg. | Daniel Goleman, *Emotional Intelligence*, 1997

"The emotional/rational dichotomy approximates the folk distinction between 'heart' and 'head'; knowing something is 'right in your heart' is a different order of conviction – somehow a deeper kind of certainty – than thinking so with your rational mind. There is a steady gradient in the ratio of rational-to-emotional control over the mind; the more intense the feeling, the more dominant the emotional mind becomes – and the more ineffectual the rational mind."

EMOTIONAL
BALANCE

EMOTIONAL
TIPPING POINT

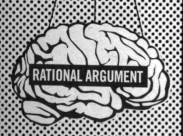

RATIONAL ARGUMENT

EMOTIONAL
INSECURITY

Emotional insecurity

Propaganda targets the emotional tipping point where the defences of rational argument collapse under the weight of emotional insecurity.

In this state of uncertainty the target audience is more likely to make rash or uninformed decisions.

It's the split second decision making where it can go completely wrong.

Eg. | Gee Thomson, *Mesmerization,* 2008

"In the modern world, fear is ever present: from petty fashion and style concerns, insecurities over our weight, looks, food and health, to the bigger crisis beyond our control: nuclear disaster, terrorist attack and climate change, and the irrational: ghouls and psychotic monks, fears govern who we are and condition how we behave and react to the world."

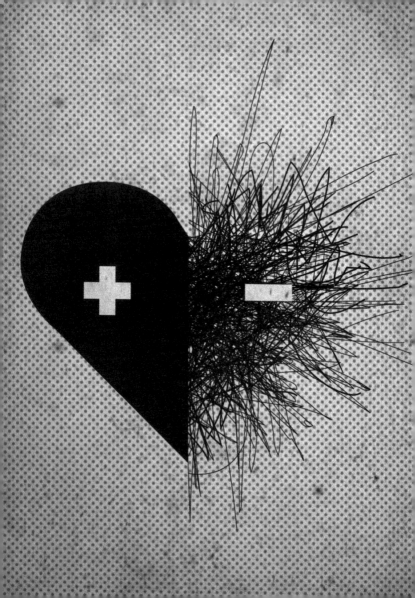

Emotional reaction

An emotional reaction can be a positive or negative response to a change in an individual's status or situation.

Emotions are like shortcuts, allowing people to make instant decisions.

When faced with a threat, the reaction is most likely to manifest in a form of panic.

 Dan Gardner, *Risk, The Science and Politics of Fear,* 2008

"Every human brain has not one but two systems of thought. System One
– Feeling... works without our conscious awareness and it is as fast as lightning.
Feeling is the source of snap judgements that we experience as a hunch or an
intuition or as emotions like unease, worry, or fear. A decision that comes from
Feeling is hard or impossible to put into words. You don't know why you feel
the way you do, you just do."

MY, WHAT

BIG

EYES

ALL THE BETTER TO SPY ON YOU WITH

YOU HAVE

⑤

HOW TO BE HAPPY:

The most jolly way to keep the herd in line. Is to maintain surveillance all the time.

STEP 6: TRIGGERS

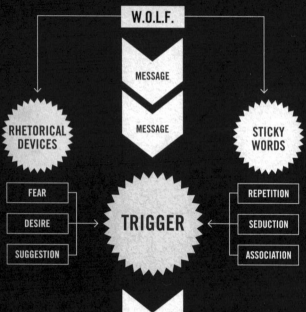

W.O.L.F.

MESSAGE

MESSAGE

RHETORICAL DEVICES

STICKY WORDS

FEAR

DESIRE

SUGGESTION

TRIGGER

REPETITION

SEDUCTION

ASSOCIATION

ACTIVATED MESSAGE

ACTIVATED MESSAGE

ACTIVATED MESSAGE

TARGET

6.0 *TRIGGERS*

These are the mechanisms contained within a message which trigger an immediate primal response.

They stimulate emotions at a subliminal level, creating automatic behaviour patterns.

Triggers can be as simplistic as a word, colour, image, smell, or tone of voice.

Pulling a trigger releases the fight or flight survival instinct.

Fear

The deepest and most potent emotion a *wolf* can prey on is fear.

Fear is triggered to scare *cows* from looking too closely at what the facts might actually be.

In a mad panic, *cows* will scramble to take cover within the safety of the herd, instead of taking time to examine the validity of the source of their fear.

 | Ben Goldacre, *Bad Science*, 2008

"Through the constant marketing of diseases, the pharma-industry is able to sustain economic growth and make profit through fear. Ironically, there are very few genuinely new treatments being developed, so 'the pill companies have instead had to invent new diseases for the treatments they already have.'"

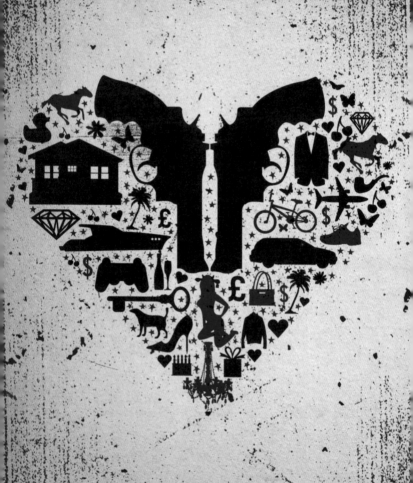

Desire

At the other end of the scale is ~~absolute~~ desire.

Desire is a strong feeling of wanting, or wishing something would happen.

In the advertising industry, desire is the most commonly pulled trigger.

When used within the context of fear, it's power is doubled.

 Adam Curtis, quoting a Wall Street banker, *The Century of Self*, 2002

"We must shift America from a 'needs' to a 'desires' culture. People must be trained to desire, to want new things, even before the old have been entirely consumed. [...] Man's desires must overshadow his needs."

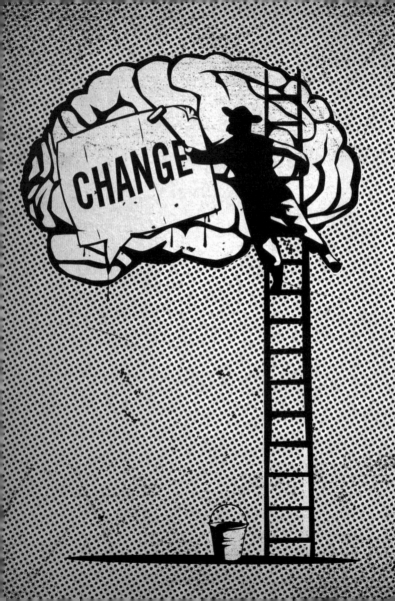

Sticky word

This is a single word which has the adhesive power to stick firmly in the mind of the herd.

It's adhesive quality is due to the fact that a multi-layered narrative has been condensed down into a simple slogan.

With a glue like quality it will hold in place as the winds of change attempt to blow it away.

 Eg. | Wolf&Co. *Tech-sneak Dept, 2010*

"Barack Obama successfully stuck two words into the public psyche during the '08 election campaign – 'Hope' and 'Change'. Both of these words carried positive connotations which the herd could easily identify with. This enabled the Obama campaign to capture hearts and minds with abstract promises and without getting bogged down in policy details."

Suggestion

Direct talks to the head. Suggest to hit the heart.

A suggestion is the process of inducing one thought which in turn triggers another.

A suggestive remark involves the linking of words, concepts or symbols.

A suggestion is most powerful when it's touch is subtle enough to leave the person unaware of where they heard it first.

Eg. | *The Art and Science of Propaganda*

"An audience is more likely to accept an idea if they believe it was heard inadvertently. There is a natural tendency to resist a message that is presented in an assertive way, while there will be far less negative reaction if the audience hears the same theme in a context that is relatively 'matter of fact.'"

THEY DID IT THEY DID IT THEY DID IT THEY DID IT THEY DID IT

Repetition

Constant bombardment & reinforcement.

A statement repeated often enough, will in time, come to be accepted by the audience as the truth.

It works simply by flooding the public domain to a point where the herd can do no more than assume that what they are hearing is the truth.

Eg. | sourcewatch.org/repetition

"If you repeat something over and over, no matter how outrageous it may be, people will come to believe there's some truth in it. A good example of this is the claim that Saddam Hussein was responsible for the terrorist attacks of September 11, 2001. No evidence has been found suggesting collaboration between Iraq and the Al Qaeda network, yet Bush administration officials repeatedly mentioned the two in tandem. As a result, an opinion survey by the Council on Foreign Relations showed that more than 40 percent of the American people believe that some or all of the attackers on 9/11 were Iraqi nationals, when in fact none were."

Seduction

Through the repetition of symbols, suggestive imagery and other stimuli, a primal lust is ~~LANGUAGE~~ triggered.

The audience can be seduced into behaving in a certain way as though under a spell, captivated by a multi-sensory spectacle. ~~A~~

~~REMOVE~~

Eg. | Gee Thomson, *Mesmerization*, 2008

"Where pleasure and excitement are bonded to particular emotions within neural maps inside the mind, re-imprinting of the same input reinforces a sense of euphoria. Just as a painter finds the sublime in a landscape, or a priest is moved by an evocative passage in the Old Testament, young minds are becoming more turned on by interacting with digital worlds and virtual partners than with interaction with real people in normal life."

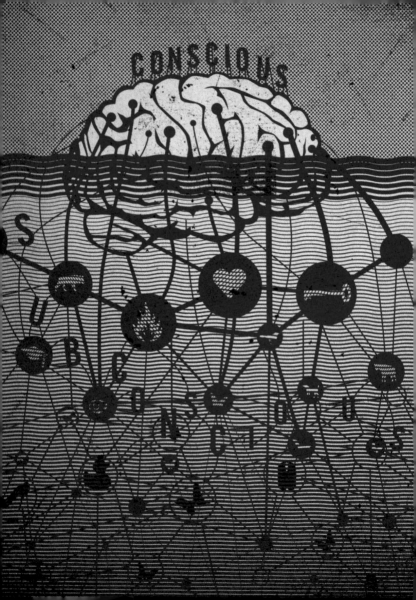

Association

Propaganda triggers emotions by activating subconscious networks of association.

A network is often based on the individual's past experiences, beginning with early childhood.

Memories buried deep down can be triggered, when their emotional associations are released – invoking behaviour change.

 | Drew Western, *The Political Brain*, 2007

"From a psychological standpoint, the primary goal of every campaign appeal should be to elicit emotions that *move the electorate*. And that means activating, reinforcing and creating networks that associate your candidate or party with positive emotions and the opposition with negative emotions."

RT
EDS

FOR YOU

6

HOW TO BE HAPPY:

*If you can
understand
and feel
their pain.
You'll learn
to twist the
blade again.*

STEP 7: SPIN

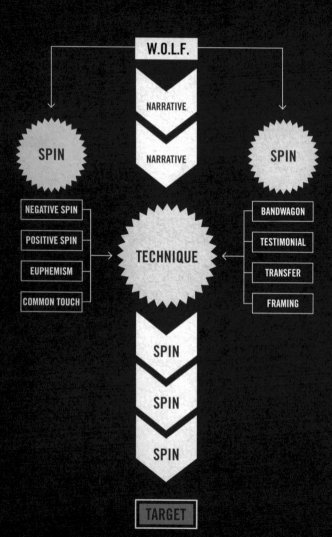

7.0 SPIN

The technique in which propaganda enters the narrative and infiltrates the audience's thoughts and feelings.

A well delivered message which has had the correct amount of spin applied to it, will allow the audience to remain unaware that any such incursion has taken place.

Blissful ignorance truly does pave the way to compliance through conformity.

Negative spin

A story is given a negative spin in the hope that the audience will reject and condemn the person or people charged, on the basis of the accusation alone, instead of looking at all of the evidence.

Eg. | Andy Greenberg, *Forbes.com*, 5/30/11

By focusing on Julian Assange, the mainstream media deliberately attempted to put negative spin around WikiLeaks so as to obscure the critical importance of the issues it champions such as publishing the truth about war and transparency in government.

"'Frontline's WikiLeaks documentary was seen by some as a negative spin on the leaking group's story that emphasized Bradley Manning's emotional problems and highlighted the accounts of WikiLeaks' critics. In response to the program, WikiLeaks released its own unedited video of PBS's interview with WikiLeaks founder Julian Assange, and warned that the show is "hostile and misrepresents WikiLeaks' views and tries to build an 'espionage' case against its founder, Julian Assange, and also the young soldier, Bradley Manning."

Positive spin

DELETE

Positive spin is given to a story in an attempt to make the audience approve and accept a person or idea without examining all of the evidence thoroughly.

Eg. | Joseph E. Stiglitz, *Vanity Fair*. May 2011

"The corporate executives who helped bring on the recession of the past three years—whose contribution to our society, and to their own companies, has been massively negative—went on to receive large bonuses. In some cases, companies were so embarrassed about calling such rewards "performance bonuses" that they felt compelled to change the name to 'retention bonuses.'"

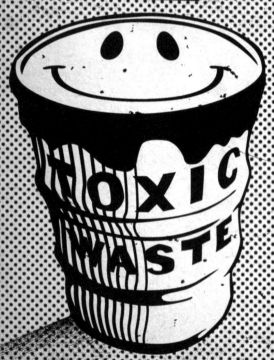

EUPHEMISTIC COVER

ACTUAL CONTENT

Euphemism

When referring to an unpleasant or embarrassing event, euphemisms can be used to make things sound better than they really are.

A euphemism is a mild or less direct word substituted for one considered too harsh, blunt... or honest.

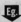

Christiaan Briggs, *Last-Straw.net*, 2010

"The euphemistic term 'ethnic cleansing' is used by governments and complicit media outlets in instances of 'genocide', where they wish to relieve themselves of their legal obligations under the Genocide Convention to 'prevent' the genocide. One of the most notorious examples of this was Srebrenica, Bosnia, 1995."

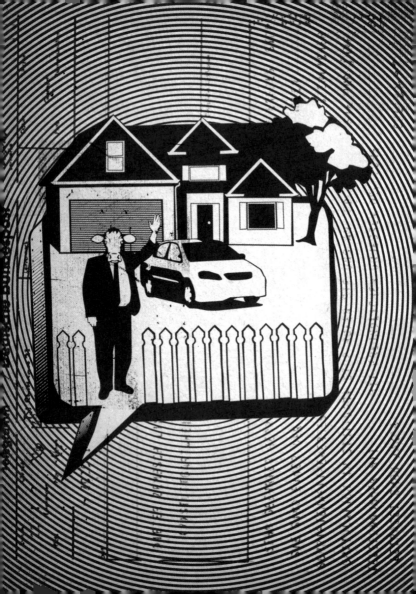

Common touch

This technique is used to give the impression that *they* hold the people's best interests close to their heart.

Emphasis is placed on the commonality of their values with that of the ordinary citizen.

Eg. | Eli Saslow, *Washington Post.com*, 2008

"Presidential candidates have strived relentlessly downward in social class ever since the 1840s... With few exceptions since, American voters have picked presidents who mimic the public's most ordinary habits – men who regularly mention drinking, or NASCAR, or old-fashioned farm work. Ronald Reagan liked to be photographed chopping wood. George H.W. Bush spoke longingly about pork rinds. Bill Clinton stopped at McDonald's while on the campaign trail, even when it required a side trip. And George W. Bush is a champion bush-clearer."

salt of the earth... level bloke...
This earns street cred.

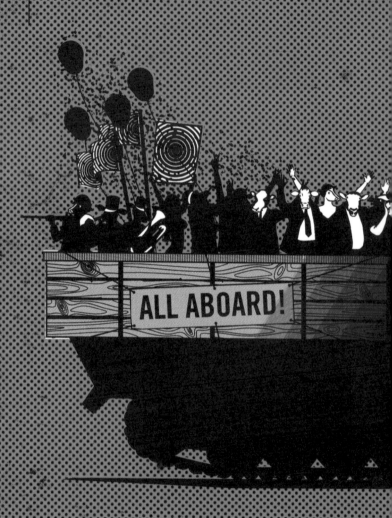

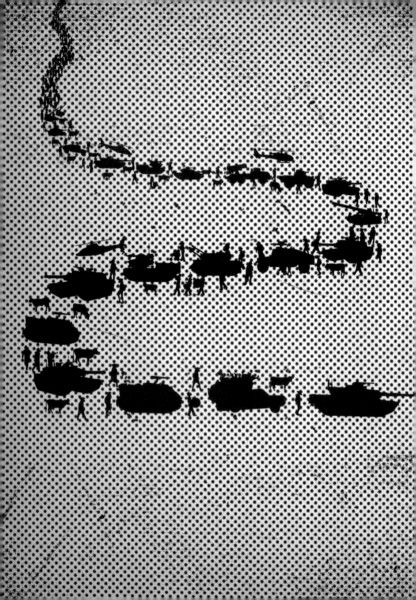

Bandwagon

The bandwagon technique is used to create the illusion that everyone is backing a particular movement. It appeals to the common desire to follow the herd, whilst reinforcing the fear of being left behind.

Eg. | [1]Steven Poole, *Unspeak, Words are Weapons*, 2006

George W Bush put the bandwagon in motion by stating "You're either with us or against us in this fight against terror" creating a false dilemma that neutrality was not an option. The idea that the international community was behind the US led invasion was perpetuated when "newspapers and TV stations adopted the phrase 'Coalition of the Willing', or even just the shorthand 'coalition', to describe the March 2003 invasion of Iraq conducted by overwhelmingly US and British forces, they quietly endorsed the idea that this was a far reaching alliance which only a few obstreperous or sulky nations opposed."[1]

Testimonial

A testimonial is an endorsement from a respected individual who holds public favour in one field, yet has no expertise in another.

DELETE

too happy

Eg. *BBC News, 22/02/03

In the lead up to the invasion of Iraq, Tony Blair visited Rome to try and obtain the Pope's blessing for the invasion. Although he failed to secure an endorsement, Blair framed the Pope's response as being a testimonial with common ground between the two: *"What the words of His Holiness the Pope have described... is the reluctance of people to go to war except as a last resort. That is our position."

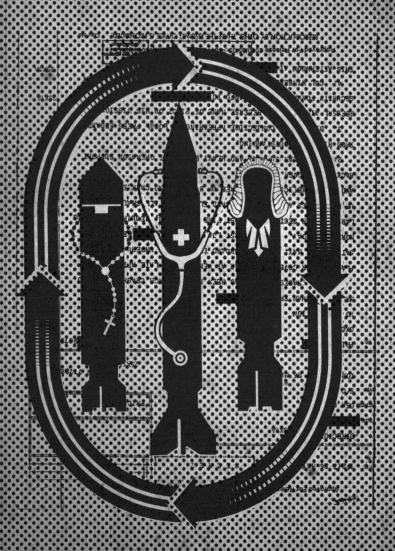

Transfer

By transferring the prestige and authority which the audience already has for a respected institution, the *wolf* secures the audience's acceptance for an agenda which may otherwise have been rejected.

Eg. | Dominic Rushe, Jill Treanor, *The Guardian*, 11/12/12

"Federal investigators found that one of the world's largest banks, HSBC, spent years committing serious crimes, involving money laundering for terrorists; 'facilitat[ing] money laundering by Mexican drug cartels'; and 'mov[ing] tainted money for Saudi banks tied to terrorist groups'. [However,] not only did the US Justice Department announce that HSBC would not be criminally prosecuted, but outright claimed that the reason is that they are too important, too instrumental to subject them to such disruptions. In other words, shielding them from the system of criminal sanction to which the rest of us are subject is not for their good, but for our common good."

This travesty of justice is able to occur due to people's blind faith in the legitimacy of authority. People accept this situation partly because the prestige of the US Justice Department has been transferred over to HSBC.

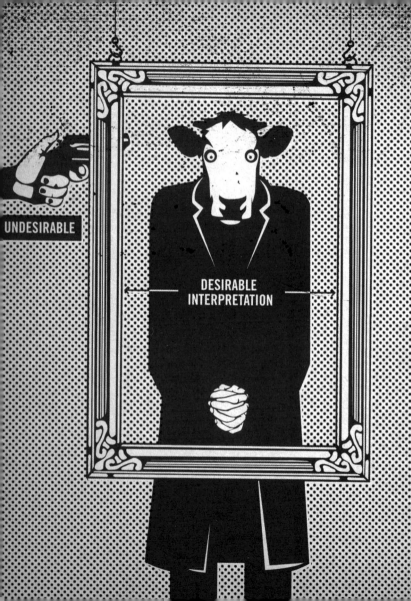

Framing

Framing is the process of selective control over message content or media communication.

Framing defines how the message is packaged so as to allow certain desirable interpretations in, and rule others out.

 ˈAddress to a Joint Session of Congress, 20/09/01

George W Bush framed the motive for the attack on 911 in strikingly narrow terms when he stated: "They hate our freedoms – our freedom of religion, our freedom of speech, our freedom to vote and assemble and disagree with each other."ˈ This statement does not allow room to consider American foreign policy as a possible motive for the atrocity.

S

NES

MAY BREAK THEIR BONES

HOW TO BE HAPPY:

Never under-estimate the strength of a word. As the ultimate way to hurt the herd.

STEP 8: FILTERS

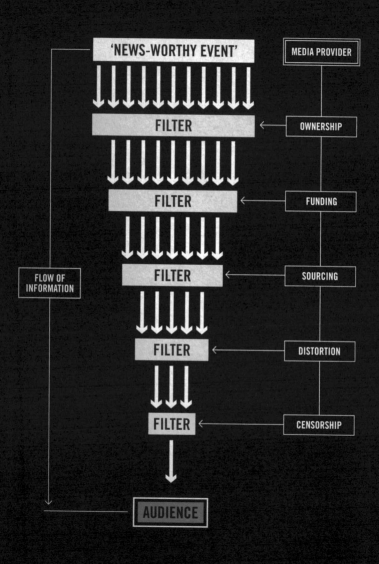

Mainstream mass media outlets are all owned and operated by large corporations.

To maximise profits they will shift their emphasis both onto and away from government and business as deemed expedient.

They are able to filter the news, fix the premise of discourse and define what is newsworthy.

The herd will happily swallow everything labeled 'news'.

Ownership

The world's media giants are essentially businesses which are profit-orientated, owned and controlled by *them,* and who have close links to other large corporations, banks and governments.

REMOVE

Eg. | Edward S. Herman & Noam Chomsky, *Manufacturing Consent,* 1988

"Leaders of the media claim that their news choices rest on unbiased professional and objective criteria... If, however, the powerful are able to fix the premises of discourse, to decide what the general populace is allowed to see, hear and think about, and to "manage" public opinion by regular propaganda campaigns, the standard view of how the [mass media] system works is at serious odds with reality."

Funding

Advertising is the primary source of funding for most mass media outlets.

As a result, media outlets rarely broadcast or print programmes or messages which are likely to upset and thereby marginalise themselves from their advertisers' patronage.

A side effect of capitalism means it's ALL for sale

Eg. | Edward S. Herman & Noam Chomsky, *Manufacturing Consent*, 1988

"Large corporate advertisers on television will rarely sponsor programs that engage in serious criticisms of corporate activities, such as... the workings of the military-industrial complex, or corporate support of and benefits from Third World tyrannies."

Sourcing

The mass media's primary source of information about, and concerning the government is provided through press releases.

This creates a convenient filter where 'experts offering objective analysis' is in reality only an echo of the official line.

 David Barstow and Robin Stein, *nytimes.com,*
Under Bush, a New Age of Prepackaged TV News, **13/03/05**

"An important instrument of this strategy [prepackaged TV news] was the Office of Broadcasting Services, a State Department unit of 30 or so editors and technicians whose typical duties include distributing video from news conferences. But in early 2002, with close editorial direction from the White House, the unit began producing narrated feature reports, many of them promoting American achievements in Afghanistan and Iraq and reinforcing the administration's rationales for the invasions. These reports were then widely distributed in the United States and around the world for use by local television stations."

Distortion

A deliberately misleading or prejudiced interpretation of events leads to a ▮▮▮▮▮ ▮▮▮▮ distortion of the truth.

By highlighting trivial aspects of a 'news story' whilst ignoring its major factors, the audience's comprehension of the event is also distorted.

Eg. | Aldous Huxly, *Brave New World Revisited*, 1958

"A dictatorship... maintains itself by censoring or distorting the facts, and by appealing not to reason, not to enlightened self-interest, but to passion and prejudice, to the powerful 'hidden forces', as Hitler called them, present in the unconscious depths of every human mind."

ultimately, this is a key foundation of controlling the masses.

Censorship

The suppression or deletion of material which may be considered harmful.

Political censorship occurs when governments hold back information from their citizens in order to exert control over the herd and prevent free expression that might encourage rebellion.

Eg. | Randy James, *time.com*, *Chinese Internet Censorship*, 18/03/09

"In China, *The Golden Shield Project* blocks web sites on an array of sensitive topics (democracy, for instance), while tens of thousands of government monitors and citizen volunteers regularly sweep through blogs, chat forums, and even e-mail to ensure nothing challenges the country's self-styled *harmonious society*."

THE TRU

JTH
HURTS

8

HOW TO BE HAPPY:

If the herd were to know all the facts. It'd be sure to cause a few heart attacks.

STEP 9: TACTICS

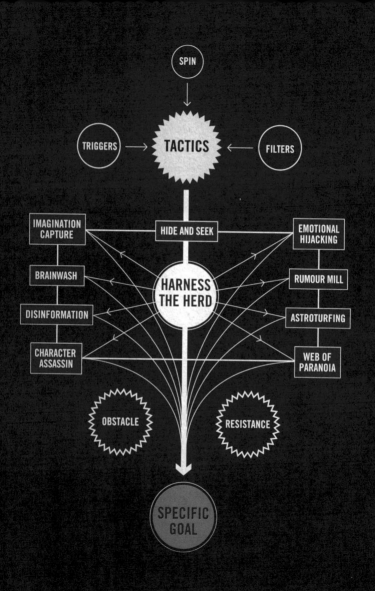

9.0 TACTICS

There are a wide variety of tactics which a *wolf* can take advantage of to harness the herd and drive *cows* in any chosen direction.

Whether it be deception, persuasion or assassination – the most appropriate method to madness needs to be found.

There will always be obstacles and resistance, so adaptability is a key attribute which the Young Cub must learn to master.

Hide and seek

When the source of propaganda is intended to be obvious – as it is with the majority of advertising, it is referred to as being 'white propaganda'.

In this case the *cow* knows who the message is from and will seek out more information if they so wish.

Where the true source is disguised, the term 'black propaganda' is used.

In an attempt to deceive and confuse the enemy further, it may be portrayed as coming from the enemy's own side of the conflict, through the fabrication of communications.

Eg. whatreallyhappened.com/cointelpro

"Black operations ... are designed to be attributed to the other side and must be carried out by a secret agency in order to hide the actual source of the propaganda. A black radio purportedly broadcasting from Central Asia or a forged document purportedly coming out of the classified files of a Soviet embassy requires expertise, secret funds, and anonymous participants."

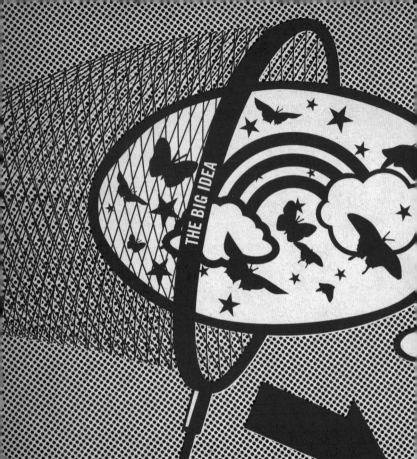
THE BIG IDEA

Imagination capture

A big idea – inspiring in it's grandeur yet deceiving in it's simplicity is what's required to effectively harness the herd.

In doing so, the *wolf* is able to capture their imagination and either motivate behaviour change or crush their will and spirit.

New thinking which blows your mind.

Eg. | George Louis (Advertising Guru), 2011

"The big idea: solving a specific communications problem with an audacious blend of words and images that catch people's eyes, penetrate their minds, warm their hearts, and cause them to act."

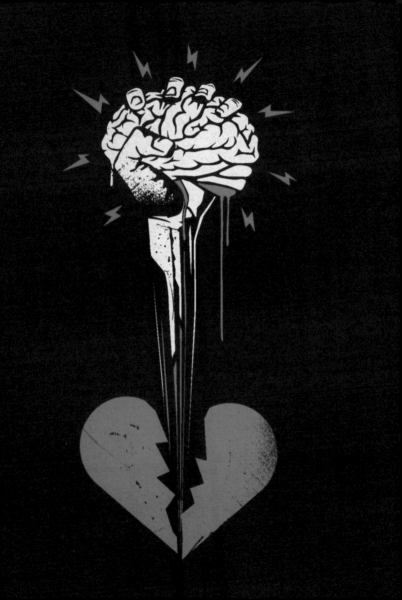

Emotional hijacking

Emotional hijacking occurs when a *cows* rational mind is overcome by his or her ~~strong~~ emotions.

This is often in response to a situation that provokes fear and subsequent panic.

As a result, an individual's decision making ability suffers.

Eg. | Daniel Goleman, *Emotional Intelligence, 1997*

"Emotional explosions are neural hijackings... a center in the limbic brain proclaims an emergency, recruiting the rest of the brain to its urgent agenda. The hijacking occurs in an instant [before] the thinking brain has had a chance to glimpse fully what is happening, let alone decide if it is a good idea. The hallmark of such a hijack is that once the moment has passed, those so possessed have the sense of not knowing what came over them."

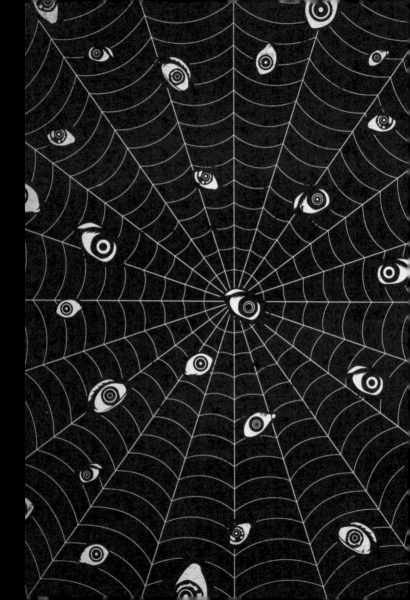

Web of paranoia

Paranoia is a disturbed mental condition characterized by anxiety, fear, and irrationality. Paranoid thinking typically includes delusions of persecution.

A *wolf* will spin the web to foster these conditions at group level, amplifying the perception of danger and inducing a state of paralysis.

Eg. | Alexander Cockburn & Jeffery St Claire, *Counter Punch. Journalism that rediscovers America,* 2002

"Americans are being slowly indoctrinated into believing that they are citizens of a nation under siege, beset by evil forces both within and without. Inspired by the Bible-thumping rhetoric of their beloved right-wing Christian leaders."

Astroturfing

REDACT

[redacted text] The term refers to the planting of supposed 'grass root' campaigners behind a politician or corporate spokesperson in position, likely to receive high media exposure, with the aim of creating the illusion of genuine support.

plant people to look popular.

Eg. | sourcewatch.org/index.php?title=Astroturfing

"Corporations such as Philip Morris Tobacco Company have funded front groups which are created by PR companies. In this case, The National Smokers' Alliance was set up as a grass roots, front group to give the appearance of genuine opposition to smoke-free laws without its corporate involvement being detected."

Disinformation

The deliberate dissemination of false information – statements and innuendo intended to manipulate the audience at a rational level.

The fabrication of intelligence is used to support false conclusions and mobilise bias.

 sourcewatch.org

"A common disinformation tactic is to mix truth, half-truths, and lies. Disinformants sometimes seek to gain the confidence of their audience through emotional appeals or by using semi-neutral language interlaced with threads of disinformation. A group might plant disinformation in reports, press releases or public statements. Disinformation is often leaked or covertly released to a source trusted to repeat the false information."

Rumour mill

He said
that she

she said

"Apparently
"they" said
that studied
that studied

A rumour is a story or report which is circulated to explain uncertain events. As a rumour spreads, it "grows shorter, more concise and is more easily grasped and told".

Rumour transmission is a type of collective explanation process.

FLOW OF INFORMATION GOSSIP TITTLE-TATTLE WHISPERS

A 'rumour mill' is a term used to refer to both the place and activity of generating rumours. Under the right conditions it is possible to manipulate or usurp the mill with the intention of pumping specific messages into the public domain.

Echo chamber

The echo chamber effect occurs when news and media outlets repeat and parrot a single source without cross-checking the facts. It reverberates throughout the press until it reaches the mainstream where it is assumed to be fact.[3]

sourcewatch.org

FLOW OF SCANDAL HEARSAY TIDBITS

Brainwashing

popular with cults

Brainwashing is a form of coercive persuasion which aims to cloud and wash away rational thought. This can result in a person being seduced into accepting what would otherwise be abhorrent.

 Kathleen Taylor, *The Guardian*, *Thought Crime*, 8/10/05

"We need to think of brainwashing more realistically: not as black magic but in secular, scientific terms, as a set of techniques that can act on the human brain to produce belief change. People do, in certain circumstances, undergo dramatic changes of belief over startlingly short periods of time."

CORE TECHNIQUES
OF BRAINWASHING

POTENT
SOURCE OF
STRESS

UNCERTAINTY

CONTROL

ISOLATION

REPITITION

EMOTIONAL
MANIPULATION

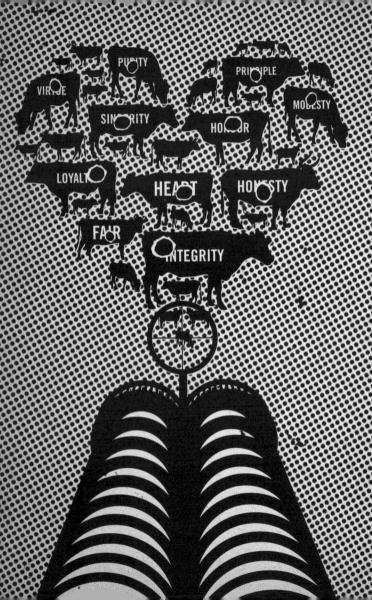

Character assassination

The intentional attempt to portray a particular person in a manner which will cause others to perceive him or her in a negative light.

By targeting the person's reputation and firing misleading innuendoes at their character it is possible to inflict a fatal blow

Eg. | Wolf&Co. *A-tactics Dept,* 2009

"*The Obama Nation: Leftist Politics and the Cult of Personality,* published during the '08 US Presidential Election Campaign was a right-wing character assassination. The author's intent was to smear Obama's reputation with claims of "extreme leftism' and 'extensive connections with Islam and radical politics.'"

L.F.

HOW TO BE HAPPY:

*Your lies
must always
manage to
deceive.
Or else the herd
won't know
who to believe.*

STEP 10: THE BLACK ART

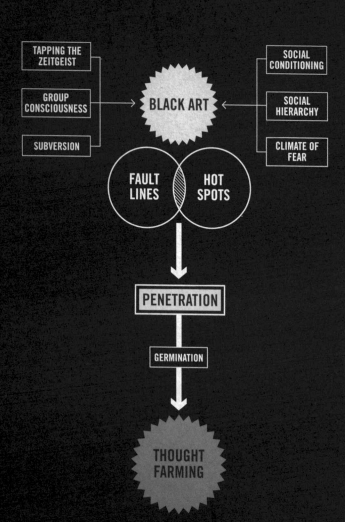

10.0 THE BLACK ART

The black art of Spinfluence is built on understanding the intangible nature of group consciousness and the ability to tap into the Zeitgeist.

This involves a meticulous examination of the herd and identification of social fault lines and hotspots.

Spinfluence is only truly achieved once the collective psyche of the herd has been penetrated and fertilised.

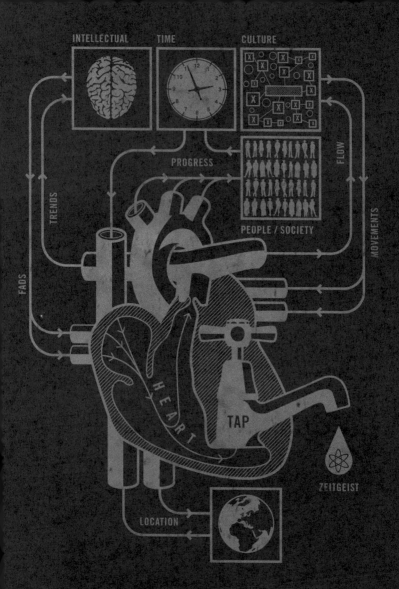

Tapping the zeitgeist

Zeitgeist translates as 'the spirit of the age' and describes the intellectual and cultural climate of an era. Tapping into the zeitgeist means being at the cutting edge of sociocultural progression. From this position, trends and movements can be identified and exploited for commercial or political gain.

 | Wolf&Co. *Morose Dept*, 2008

"Contemporary culture is dominated by the 'cult of celebrity' – the mass idolisation of popular culture personalities. A *wolf* should learn to exploit these cult followings by persuading its figureheads to endorse an idea or product. Equally, the cult of celebrity is useful in deferring attention from unwanted press. Newsworthy stories move to the back pages as papers fill their prime space with celebrity gossip and scandal."

Group consciousness

The ideas and beliefs which are held in common, bind together to form the group's consciousness.

This acts as a psychic gateway into the heart of the community.

The secret to Spinfluence is selecting the right key with which to unlock the gate. Once inside, the *wolf* is free to prey upon the values which are fundamental to the community's sense of identity.

Eg. | Jacques Ellul, philosopher, 1912 – 1994

"Emotional ideas, ranging from hopes to fears are what provide the richest material for the grand themes of propaganda. Tapping into these ideas and predicting the relevant ones and which ones hold the most sway with the greatest majority is what the propagandist studies. The goal of modern propaganda is no longer to transform opinion but to arouse an active and mythical belief."

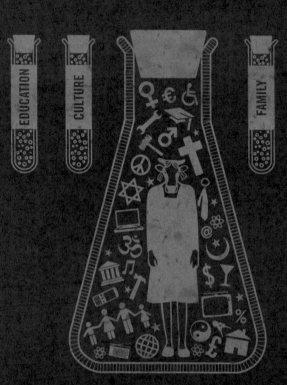

EDUCATION CULTURE FAMILY RELIGION

Social conditioning

Social conditioning refers to the absorption of social patterns, structures and codes of conduct, through influencing elements such as education, popular culture, family life and religion.

Cows are fully conditioned members of society who have adopted most, if not all, forms of conformist behavior.

 Erich Fromm, *To Have or to be?*, 1997

"The growing person is forced to give up most of his or her autonomous genuine desires and interests, and his or her own will and to adopt a will and desires and feelings that are not autonomous but superimposed by the social patterns of thought and feeling. Society, and the family as its psychosocial agent, has to solve a difficult problem: How to break a person's will without his being aware of it? Yet by a complicated process of indoctrination, rewards, punishments, and fitting ideology, it solves this task by and large so well that most people believe they are following their own will and are unaware that their will itself is conditioned and manipulated."

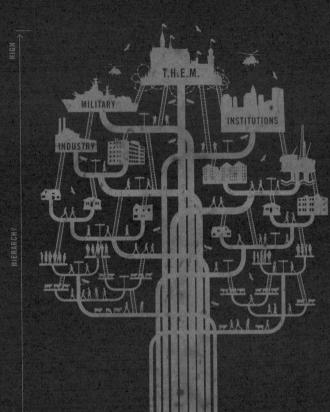

HIGH

T.H.E.M.

MILITARY

INSTITUTIONS

INDUSTRY

HIERARCHY

LOW

DYNAMICS

Social hierarchy

Social hierarchy is the ranking of people or groups above and below each other in accordance with their status and authority.

A *wolf* understands the common desire to move upwards and fools the herd into believing they are doing so, when in fact any progress is restricted to the lower branches of society.

 Gee Thomson, *Mesmerization*, 2008

"Competitive concerns, anxieties over our status and our positional worth compared to our neighbours, friends and family are some of the most powerful controllers of behaviour. In contemporary culture, such comparisons are that much more acute when those 'friends' and 'neighbours' are the world's most glamorous celebrities, brought into the intimacy of our homes by reality TV, the internet and lifestyle magazines."

Fault lines and hotspots

Fault lines run along cultural divides such as race, religion and social status. A *wolf* will identify a hot spot of intolerance and fan the flames of bias to ignite radicalisation. Intolerance towards the other group's differences turns fault lines into open divides. Once divided, the herd is easily conquered.

Eg. | Gee Thomson, *Mesmerization*, 2008

"Resignation of one's autonomy to the group... devolves one of responsibility. Scientific research has shown that we have a natural propensity to form groups for our own protection. Part of that defence includes a prejudice to those outside our circle. Such discriminations can easily be inflamed to create radicalisation and violence."

PERCEPTION OF DEMOCRACY

ESTABLISHMENT / AUTHORITY

TRUTH · JUSTICE · LIBERTY

SUBVERTED ESTABLISHMENT / AUTHORITY

TRUTH

JUSTICE

LIBERTY

TRUTH

JUSTICE

LIBERTY

REALITY OF DEMOCRACY

Subversion

A *wolf* builds up trust with the herd by portraying our client as having integrity and strong moral conviction. Once this position has been established, the *wolf* is able to undermine and subvert these very values which were proudly displayed.

Once integrity is subverted, corruption becomes inevitable.

 Eg. | Anon, source unknown

"Democracy is subverted when a foreign power installs and supports a puppet regime in the name of freedom and independence for the people. This has been the case for many Central and South American military dictatorships which the U.S. has covertly supported to further their foreign policy objectives, despite a great loss of life."

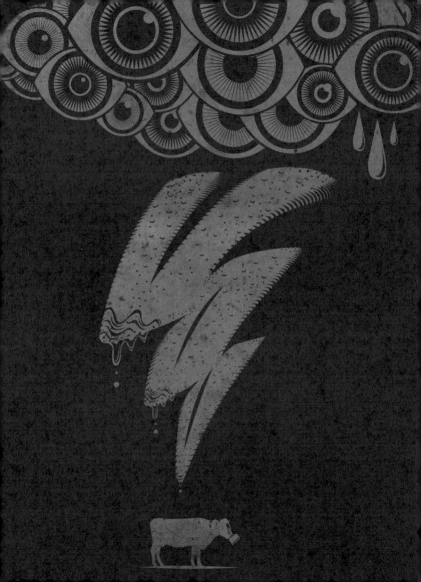

Climate of fear

The desired atmosphere in which to foster paranoid subservience, is one of toxic anxiety with the occasional lightning bolt of outright terror.

Fear drives the media. Media drives hype. And hype drives fear. It is these factors, kept in constant motion which creates a perpetual climate of fear.

 Dan Gardner, Risk. *The Science and Politics of Fear*, 2008

"The media are in the business of profit, and crowding in the marketplace means the competition for eyes and ears is steadily intensifying. Inevitably and increasingly, the media turn to fear to protect shrinking market shares because a warning of mortal peril – 'A story you can't afford to miss!' – is an excellent way to get someone's attention."

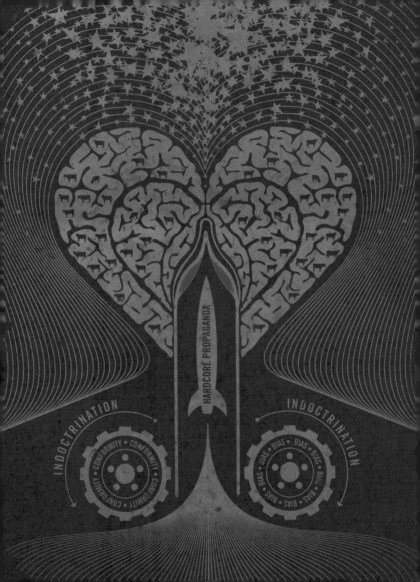

Penetration

Penetration involves the ~~[REPU...]~~ process of inserting and seeding messages into the collective psyche of the herd – through subversive or non-consensual methods.

In doing so, their hearts and minds become impregnated with the desired ideas.

 sourcewatch.org

"Some scholars refer to propaganda as a 'hypodermic approach' to communication, in which the communicator's objective is to 'inject' his ideas into the minds of a target population."... This is quite different from the democratic model, which views communications as a dialogue between presumed equals. The goal of the propaganda model is simply to achieve efficient indoctrination, and it therefore tends to regard the assumptions of the democratic model as inconvenient obstacles to efficient communication."

Germination

Once the seed has been planted, a period of incubation is required.

During this time, the idea will begin to lay it's roots deep into the *cows* psyche.

This is a delicate stage of the process, as in it's embryonic form the idea's survival is dependent on a hospitable environment.

 Rod Serling, 1924 ~ 1975

"The tools of conquest do not necessarily come with bombs, and explosions, and fallout. There are weapons that are simply thoughts, ideas, prejudices, to be found only in the minds of men. For the record, prejudices can kill and suspicion can destroy. A thoughtless, frightened search for a scapegoat has a fallout all its own for the children yet unborn."

Thought farming

The seedling-thoughts which sprout up need to be nurtured until firmly established.

Conflicting ideas must be regularly purged of the environment until the desired thoughts have had a chance to mature. Once fully grown, these prejudice mind-sets are harvested – yielding the conformist and obedient behaviour which is the desired outcome of Spinfluence.

Eg simplypsychology.org/obedience

"Millions of people were killed in Nazi Germany in concentration camps but Hitler couldn't have killed them all, nor could a handful of people. What made all those people follow the orders they were given? Were they afraid, or was there something in their personality that made them like that? In order to obey authority, the obeying person has to accept that it is legitimate (i.e. rightful, legal) for the command to be made of them."

PILY

EVER AFTER

HOW TO BE HAPPY:

*A fairy-tale
ending is
what we crave.
As anything less
will produce an
early grave.*

Congratulations
Young Cub

You have completed reading the 10 steps of:

SPINFLUENCE
— THE —
HARDCORE PROPAGANDA MANUAL

FOR CONTROLLING THE MASSES

We trust you have found this manual enlightening whilst you have prepared to become a fully qualified Warden Of Language & Falsities. There is one last lesson to be learnt. You are now invited to open the sealed section on the following page. Read the final words with care and devour their meaning.

Only once you've looked *them* in the eye and absorbed the hidden truth within your heart, will we consider you worthy of becoming a *wolf*. Only then will you be allowed to pledge your allegiance to Wolf&Co.

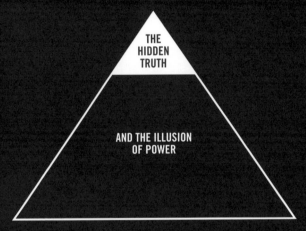

THE
HIDDEN
TRUTH

AND THE ILLUSION
OF POWER

The truth is known to hurt, and what follows may do so, as the moral of our story becomes painfully clear. It is important you understand that with the immense power you will shortly gain, comes great responsibility. It is now up to you Young Cub, to grasp the magnitude of why we serve *them*. Let the following be of warning:

T.H.E.Y. represent only 1% of the
population, yet own the majority
of wealth and are able to control
the rest of society.

They do so by remaining hidden
at all times, and understanding
the power of Spinfluence.

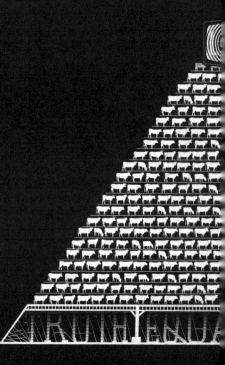

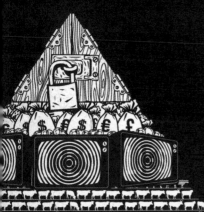

They have fooled the herd into thinking that *they* are too strong to ever be challenged.

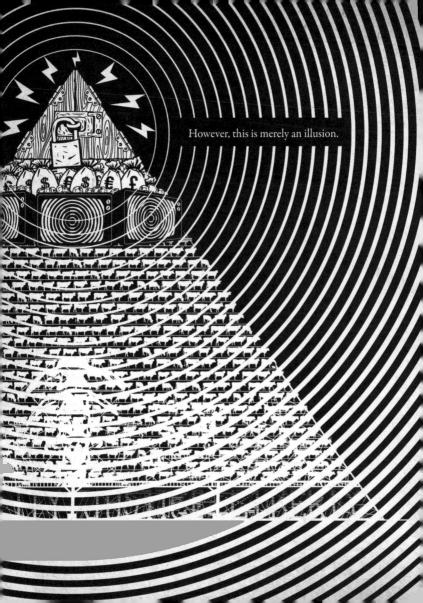

However, this is merely an illusion.

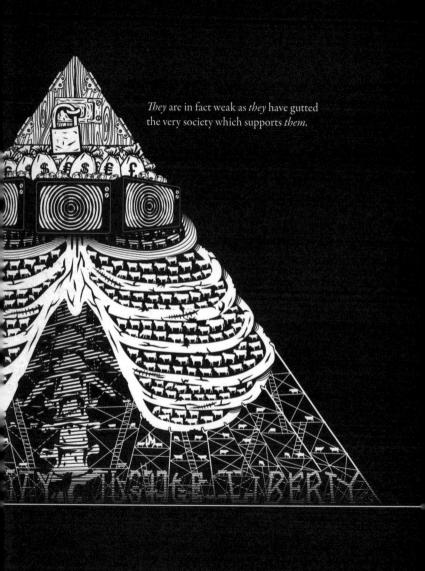

They are in fact weak as *they* have gutted
the very society which supports *them*.

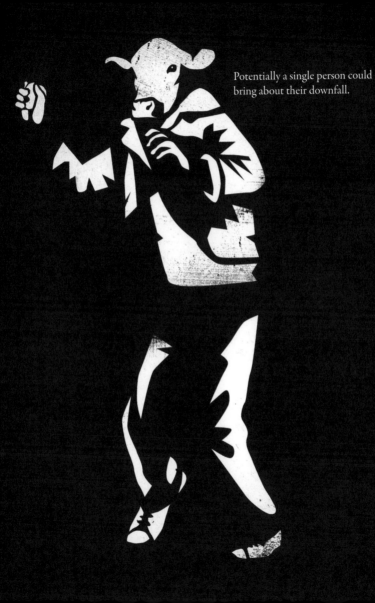

Potentially a single person could bring about their downfall.

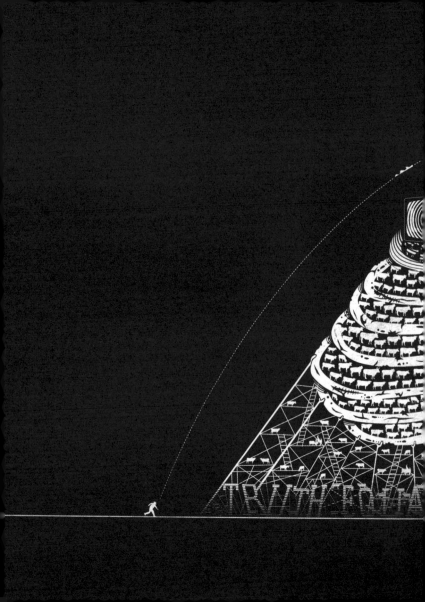

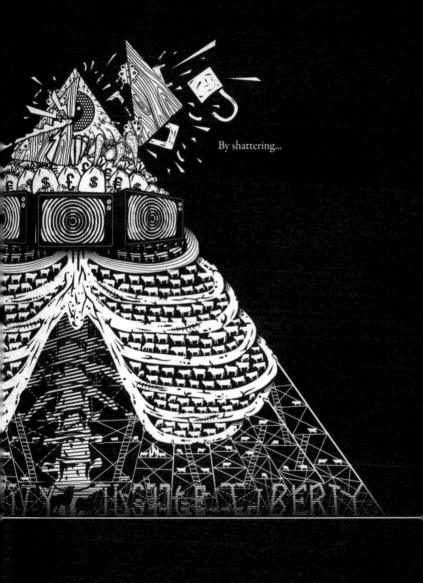

By shattering...

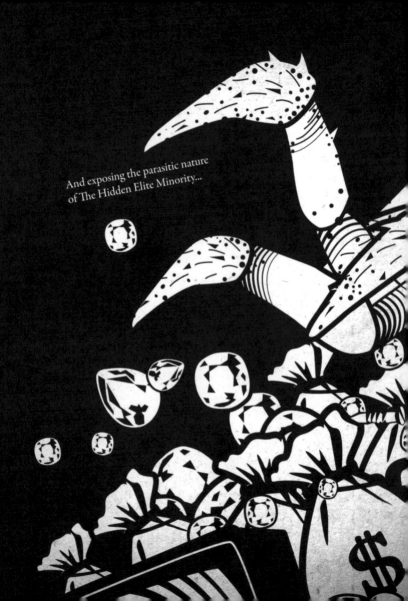

And exposing the parasitic nature
of The Hidden Elite Minority...

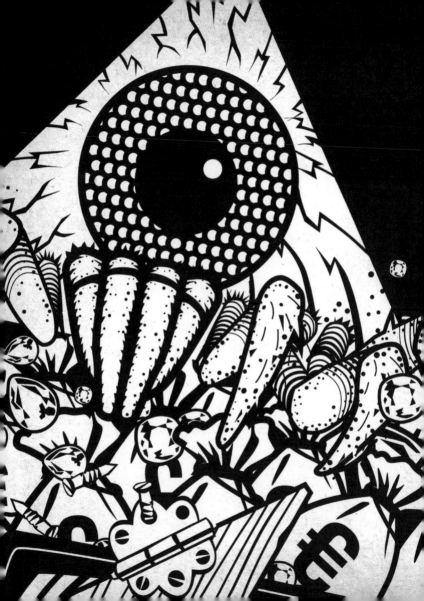

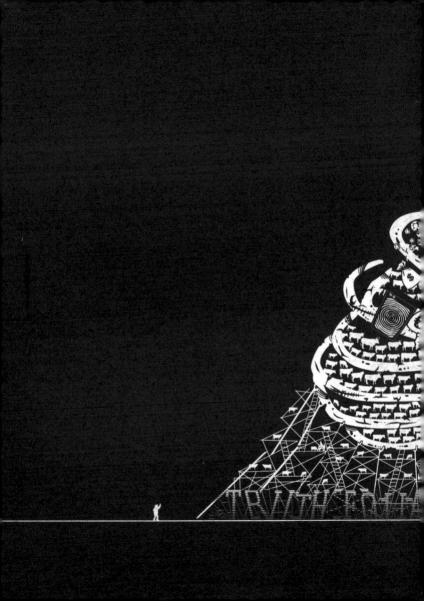

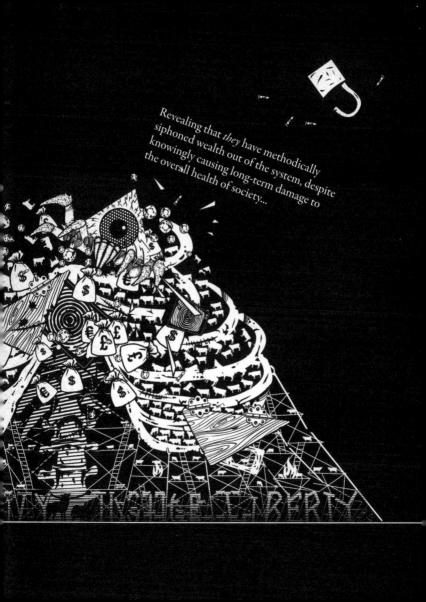

Revealing that *they* have methodically siphoned wealth out of the system, despite knowingly causing long-term damage to the overall health of society...

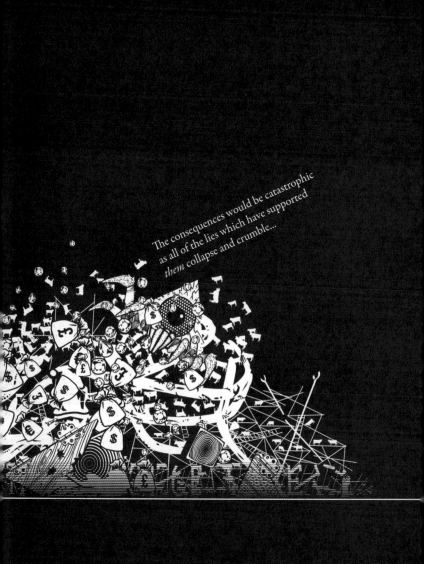

The consequences would be catastrophic as all of the lies which have supported *them* collapse and crumble...

It is only due to the excellent quality of Spinfluence that Wolf&Co. provide which allows *them* to remain in power and keeps the herd subservient.

Thus, ensuring that the scenario depicted here never eventuates...

Because the thing which
scares *them* the most...

Is someone who sees through the lies...

can see that *they* are weak...

and rejects...